COLORING

←— THE —→

National Parks

FEATURING 34 PARKS
ACROSS THE COUNTRY

ARTWORK BY MEGGYN POMERLEAU

GRAPHIC ARTS BOOKS®

Acadia National Park (Maine)

Making up most of Mount Desert Island, Acadia is the oldest national park in the
US east of the Mississippi River, and the only national park in the entire Northeast US.
Bass Harbor Head Light, built in 1858 from brick, is the only lighthouse on the island.

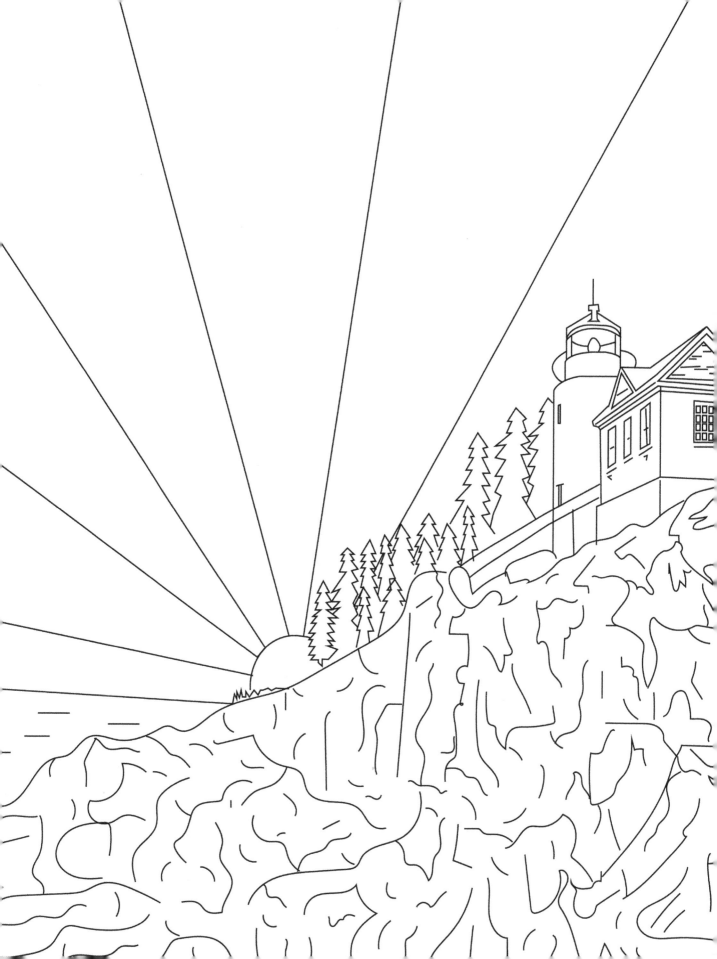

Arches National Park (Utah)

More than 2,000 natural sandstone arches can be found in this park, making Arches contain the highest density of natural arches in the world. The world-famous Delicate Arch is the park's largest free-standing arch, the light opening being 46 feet high and 32 feet wide.

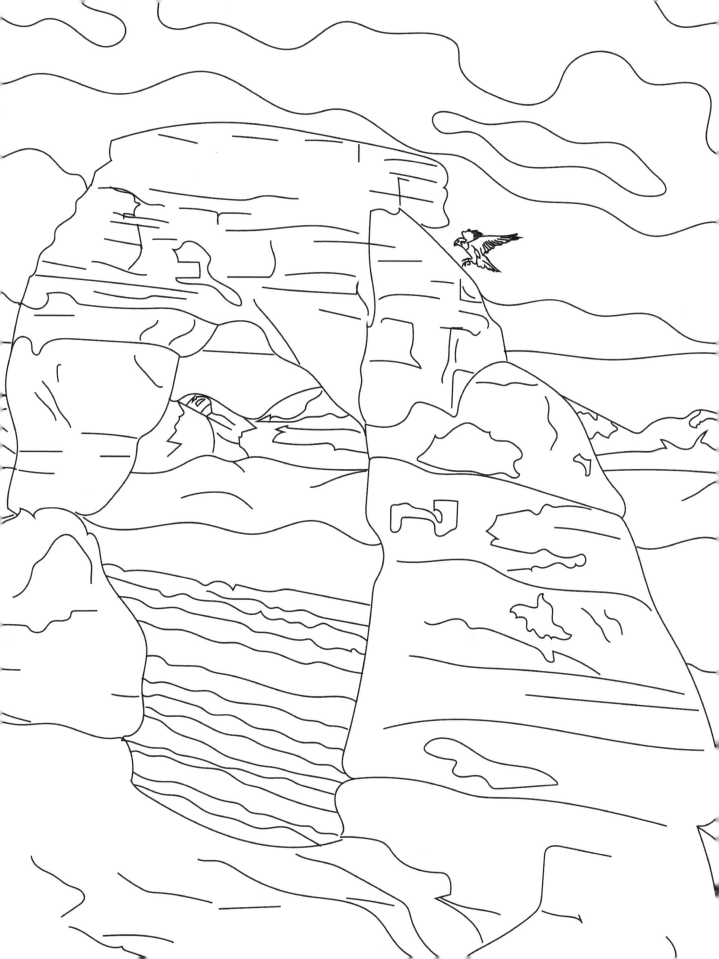

Badlands National Park (South Dakota)

The Badlands is largely managed by the National Park Services, with the South Unit co-managed by the Oglala Lakota tribe. The White River Badlands contain one of the world's richest fossil beds that may be up to 33 million years old.

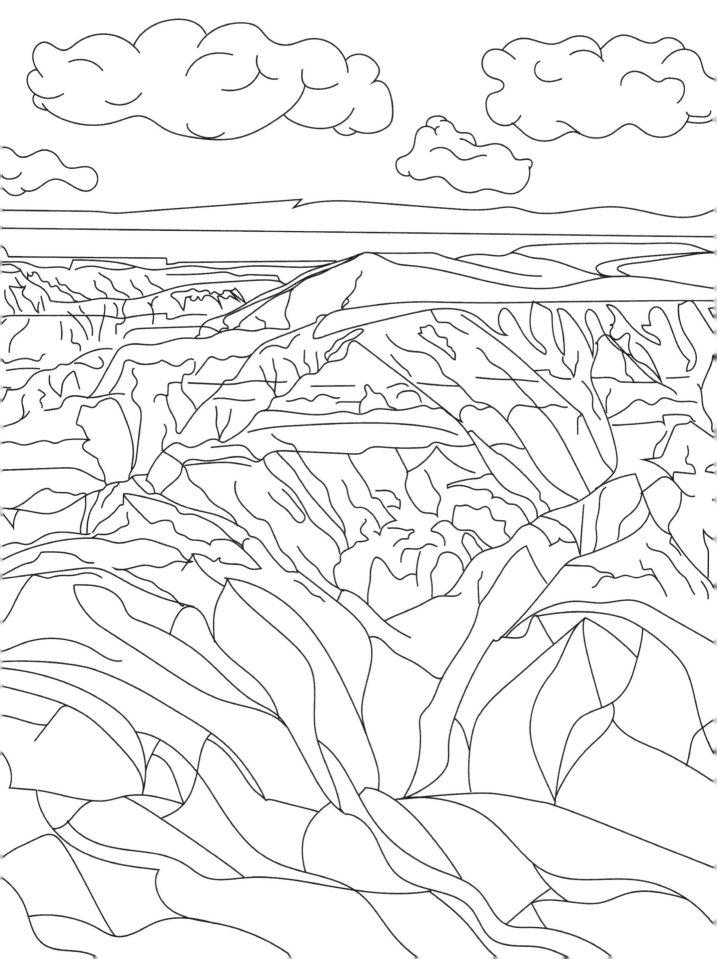

Biscayne National Park (Florida)

Ninety-five percent of Biscayne is water, its most distinguishable feature being the mangrove forests. The iconic ornamental Boca Chita lighthouse was built in the 1930s by Mark Honeywell, the previous owner of the island, so he could spot the island when traveling across the bay.

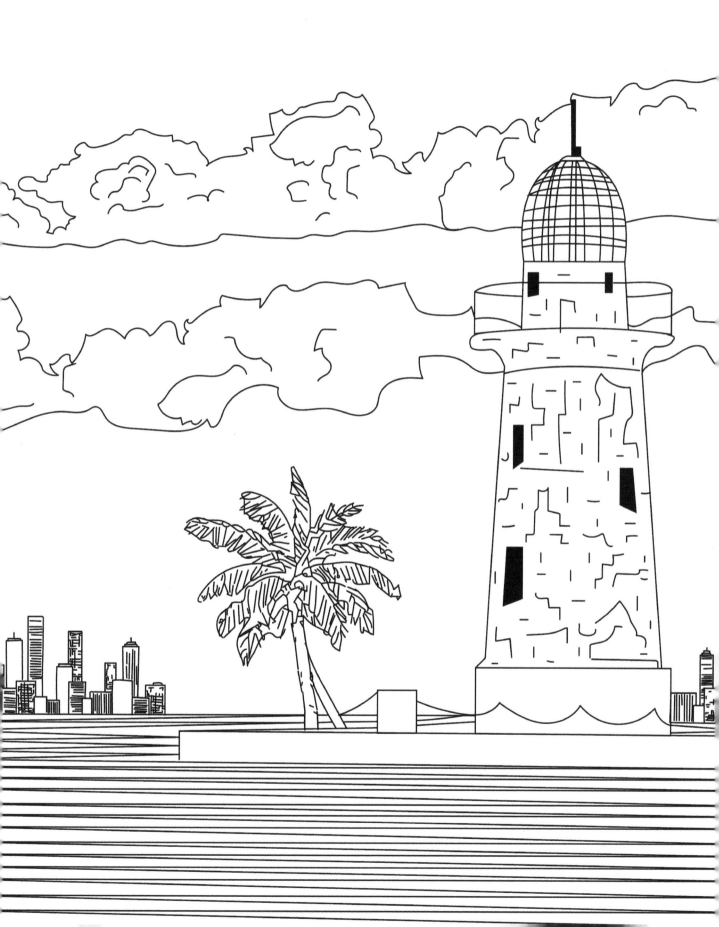

Bryce Canyon National Park (Utah)

Bryce Canyon is known for geological structures called hoodoos, which are spires of rocks formed by frost and rain erosion. The hoodoos in Bryce Canyon can be as tall as a 10-story building and 30–40 million years old.

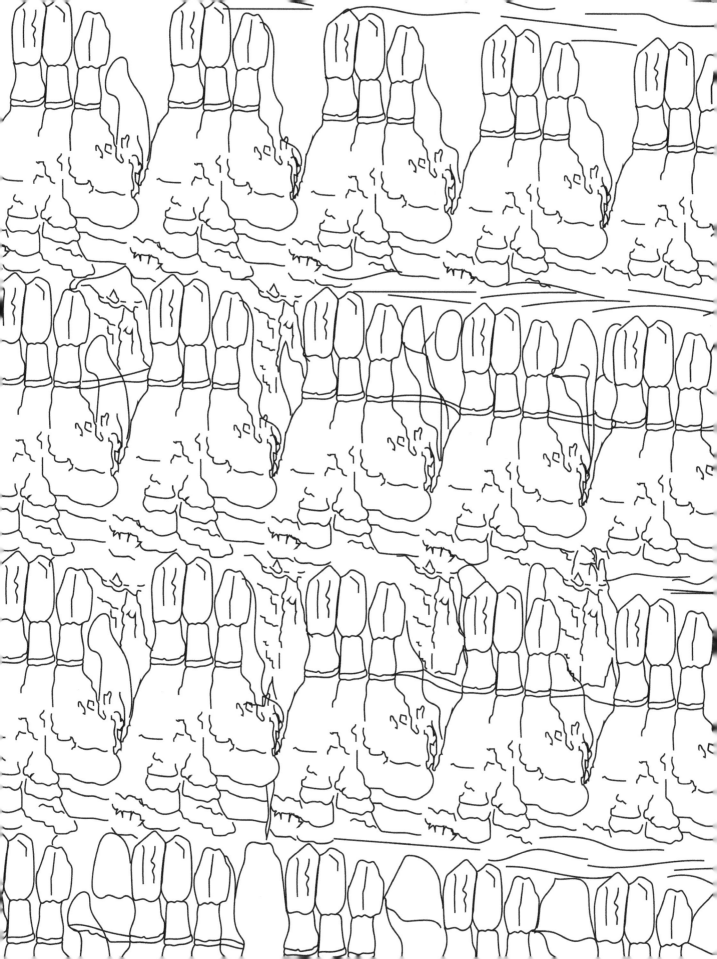

Capitol Reef National Park (Utah)

Capitol Reef is defined by the Waterpocket Fold, a warp in the earth's crust that may be as old as 65 million years old. In the South Desert, Jailhouse Rock looms impressively at 500 feet.

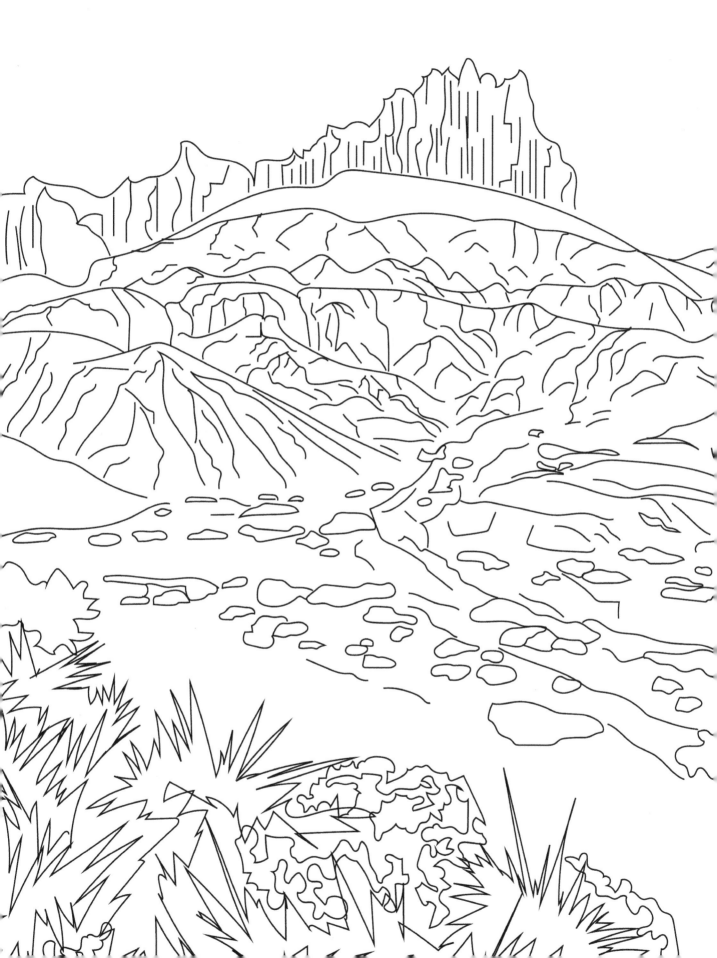

Carlsbad Caverns National Park (New Mexico)

The Carlsbad Caverns, located in the Guadalupe Mountains, are one of the oldest and most famous cave systems. The Big Room is the largest chamber in the caverns, made of limestone and featuring cave formations like the Chinese Theater, the Doll's Theater, the Hall of Giants, and more.

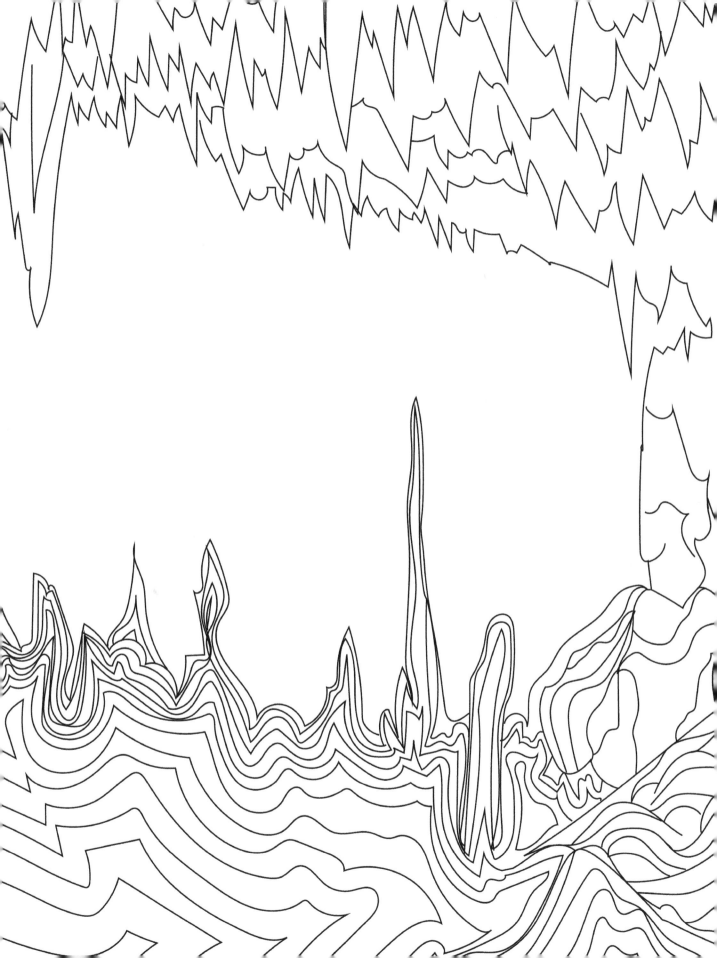

Crater Lake National Park (Oregon)

The fifth oldest national park in the US, Crater Lake is located where a dormant volcano had collapsed after a major eruption more than 7,000 years ago. The lake is 1,943 feet at its deepest, making it the deepest lake in the US, and is perhaps the cleanest, most pristine large body of water in the world.

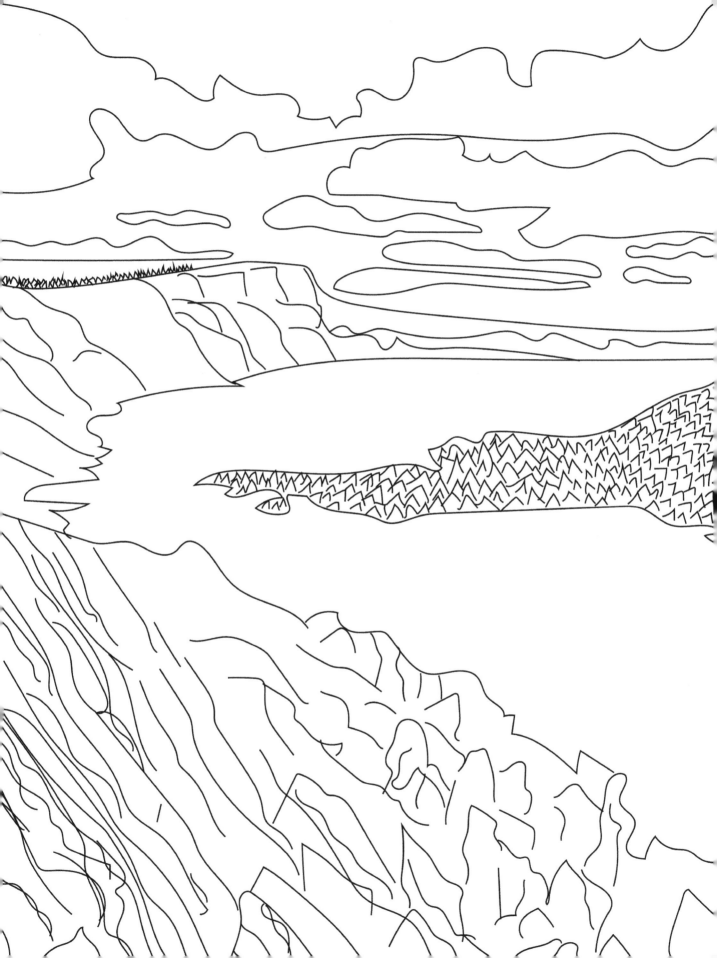

Cuyahoga Valley National Park (Ohio)

The Beaver Marsh in Cuyahoga Valley National Park is one of its most popular spots for wildlife and scenery. Named for the beavers that built a system of dams that flooded the area, the marsh also hosts herons, muskrats, songbirds, ducks, turtles, and many more species.

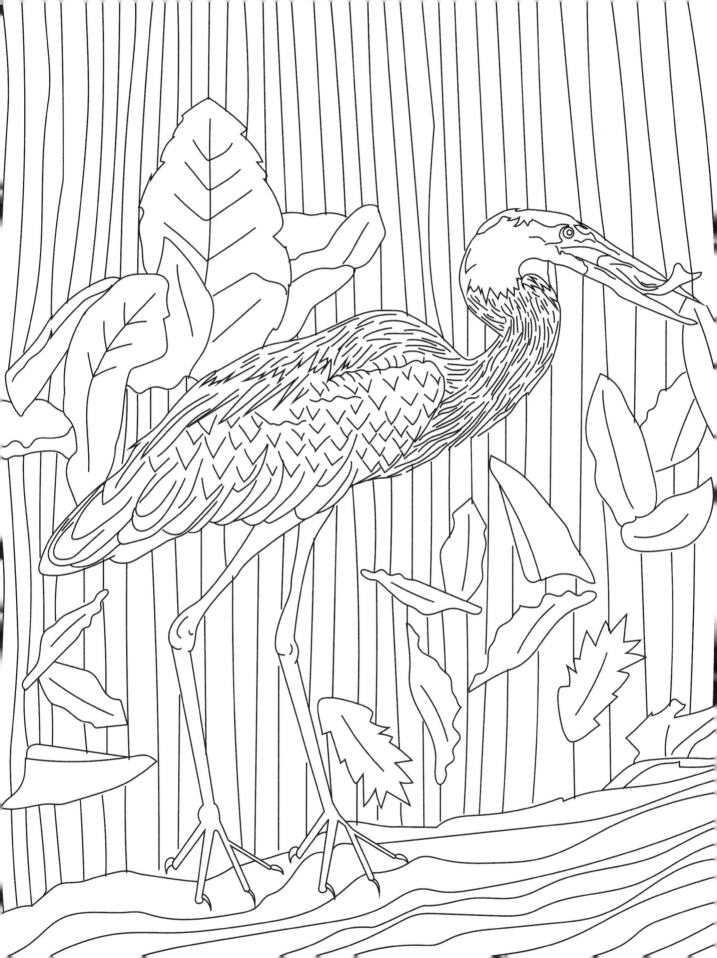

Death Valley National Park (California, Nevada)

Death Valley is the hottest, driest, and lowest national park in the US, and features lands of many extremes, though sand dunes cover less than 1 percent of it. The Mesquite Flat Dunes rise up to about 100 feet and are just one of seven sets of dunes in the park.

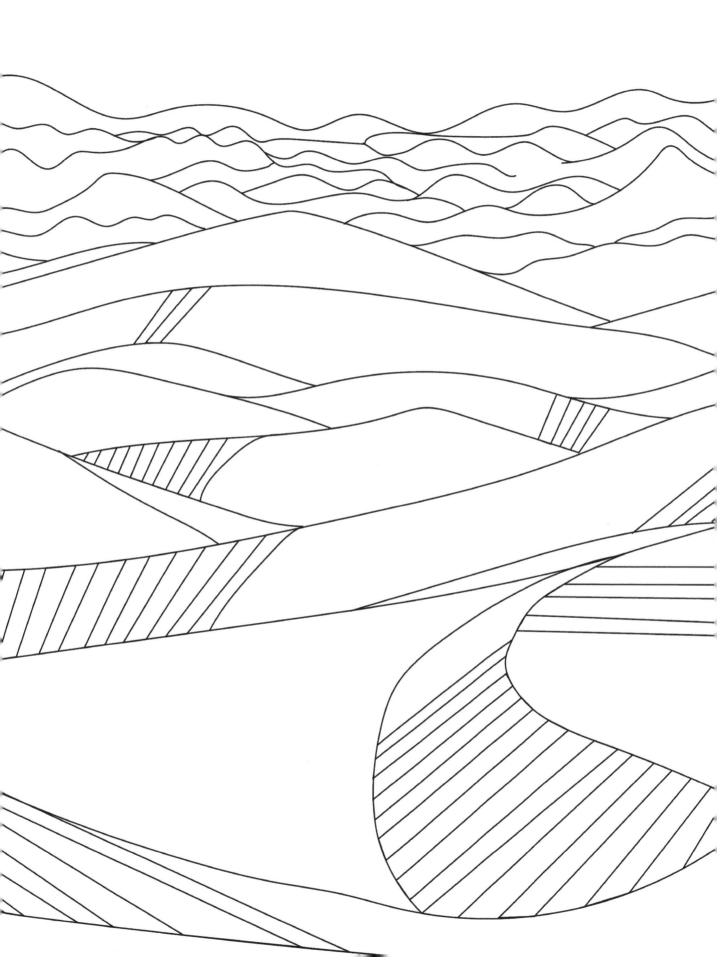

Denali National Park and Preserve (Alaska)

Formerly known as Mount McKinley until renamed in 2015, Denali is the highest mountain in North America at 20,310 feet. Permanent snow and ice cover over 75 percent of the mountain, and glaciers are attached to its base.

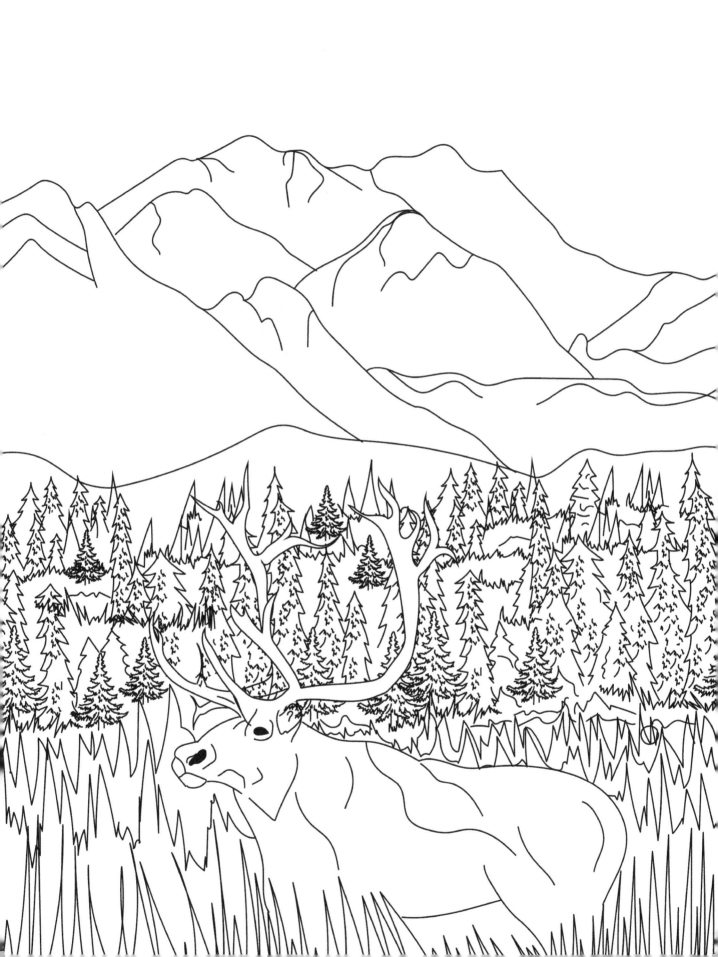

Everglades National Park (Florida)

The Everglades is the largest subtropical wilderness in the US, where many rare
and endangered species call home. Because of its unique ecosystem, the Everglades
is a World Heritage Site, International Biosphere Reserve, Wetland of International Importance,
and also a protected area under the Cartagena Treaty.

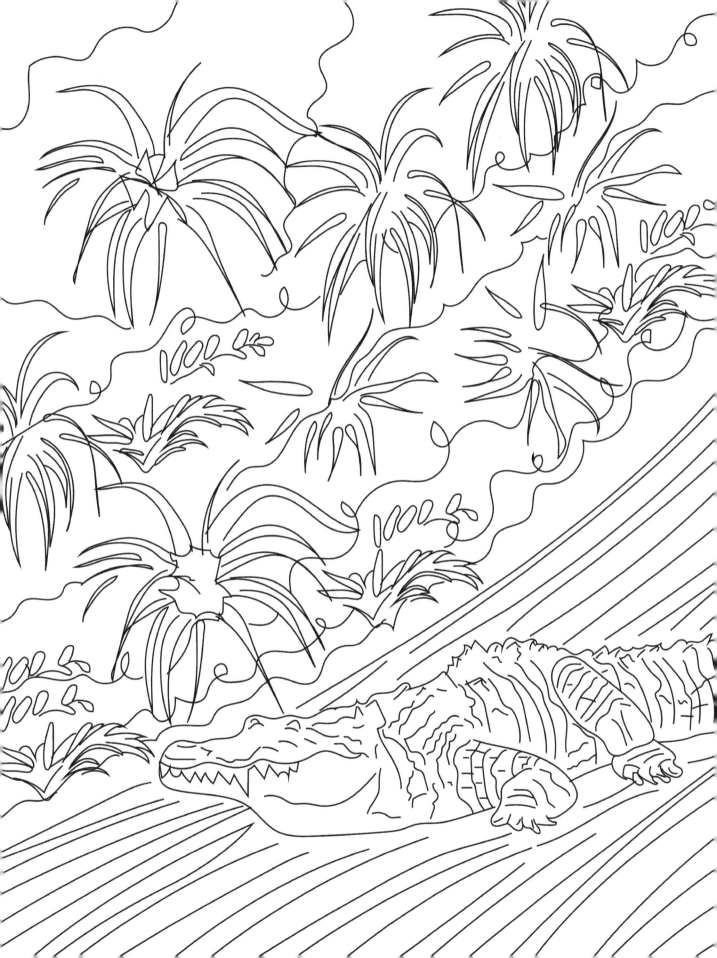

Glacier National Park (Montana)

With Waterton Lakes, Glacier National Park is the world's first international
peace park and a World Heritage Site, and is also a Biosphere Reserve.
Hidden Lake is one of Glacier's most visited places, where fishing is catch-and-release.

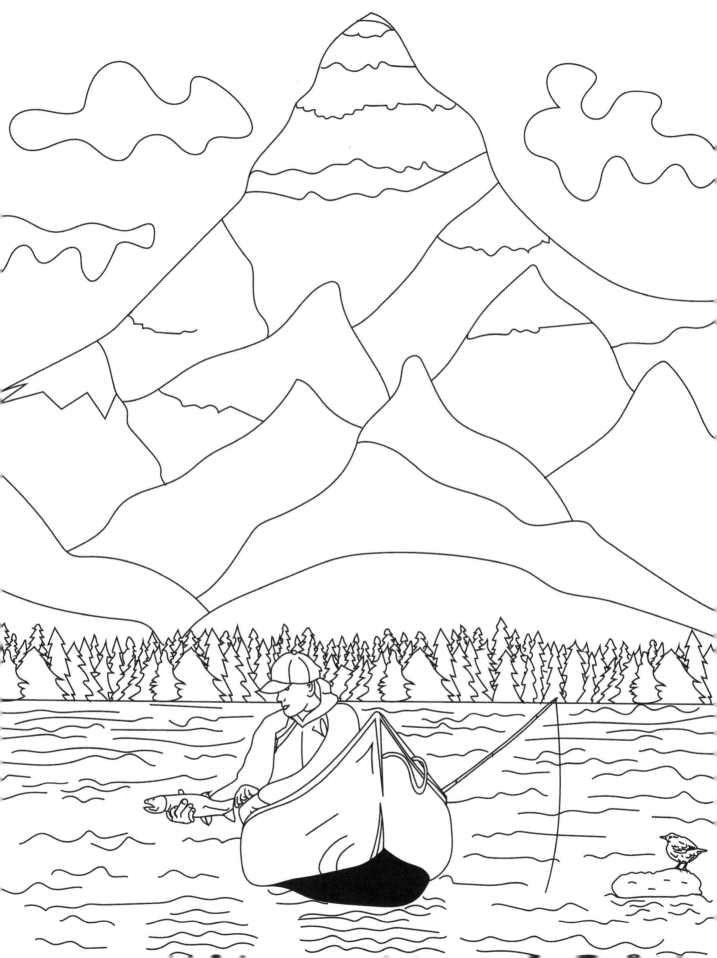

Glacier Bay National Park (Alaska)

Over 1,000 glaciers cover about 27 percent of Glacier Bay National Park, a highlight of Alaska's Inside Passage. The park's marine world is home to Steller sea lions, harbor seals, sea otters, porpoises, and humpback whales, while on land there are moose, porcupine, mountain goats, and bears.

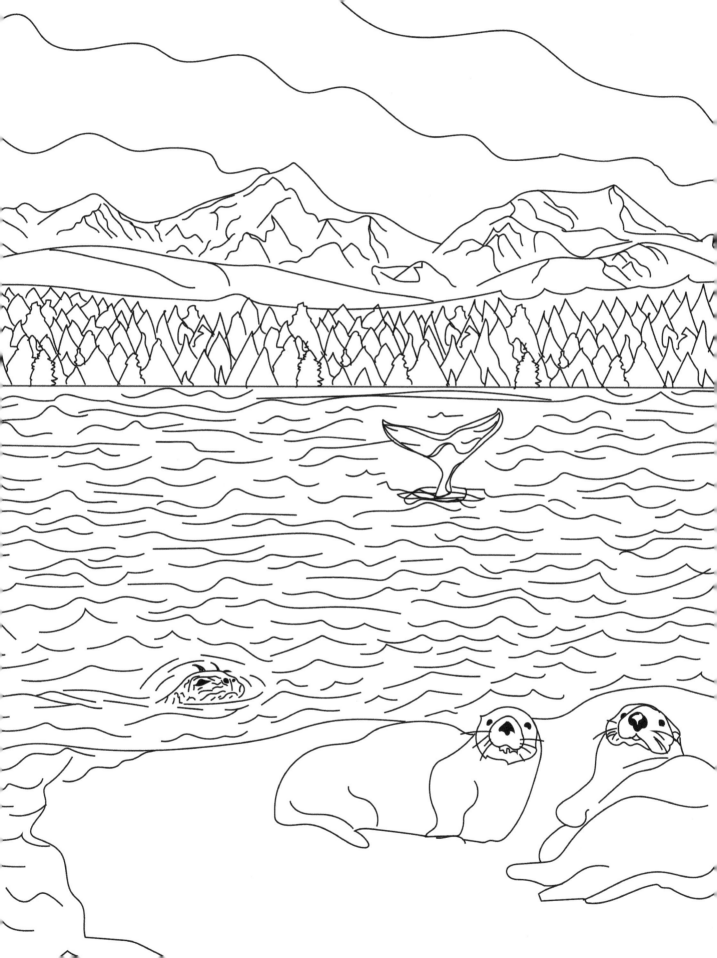

Golden Gate National Recreation Area (California)

Made up of a collection of areas, the Golden Gate National Recreation Area includes Alcatraz Island, famously known for the notorious prison that housed America's most infamous criminals (like Al Capone) as well as being the site of the first US lighthouse on the West Coast, a military fort during the Civil War, and an important Native American protest movement.

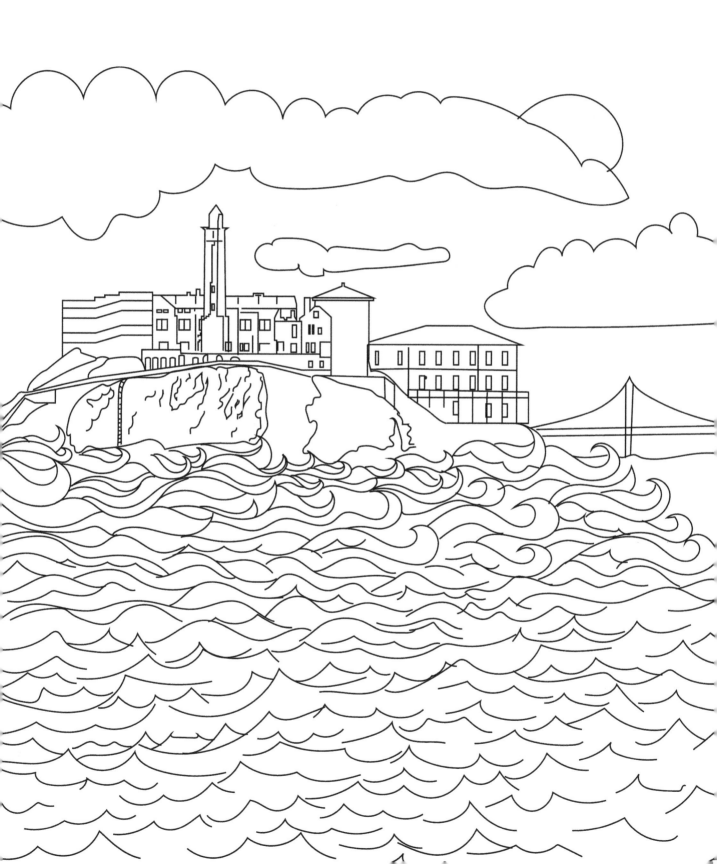

Grand Canyon National Park (Arizona)

Carved by the great Colorado River 5–6 million years ago, the Grand Canyon is a mile deep and up to 18 miles wide. The canyon walls expose layers of Earth's history and hold ancient fossils hidden within, though none of dinosaurs as the canyon's rocks predate even the oldest known dinosaurs.

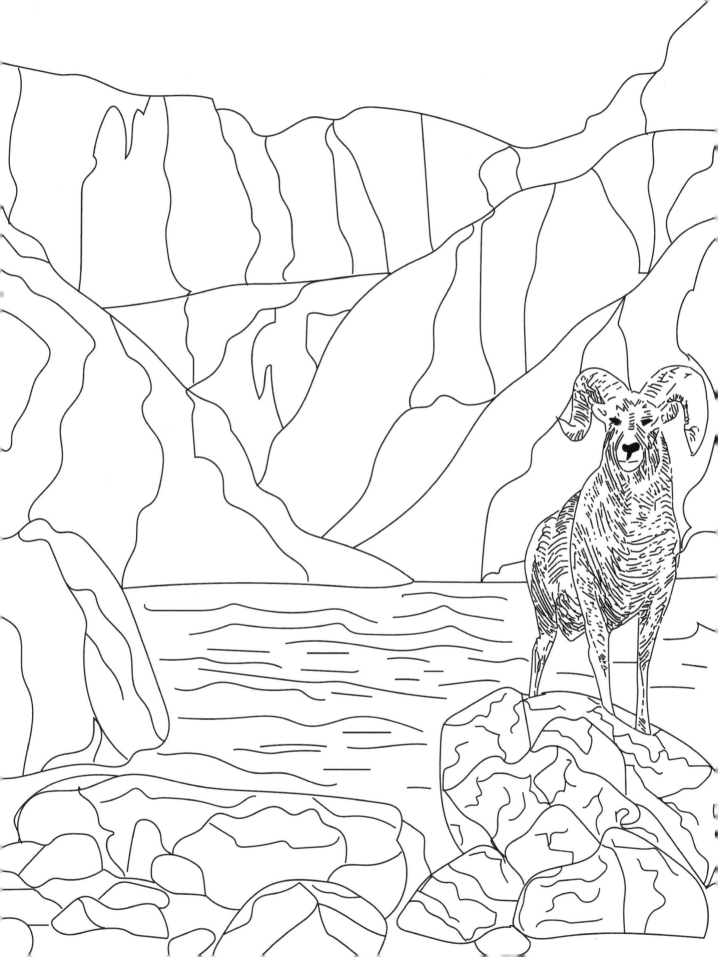

Grand Teton National Park (Wyoming)
The 40-mile-long Teton Range is a segment of the Rocky Mountains and
towers over lakes, plains, and abundant wildlife—from golden eagles, bears,
and coyotes to herds of bison, moose, snakes, and more.

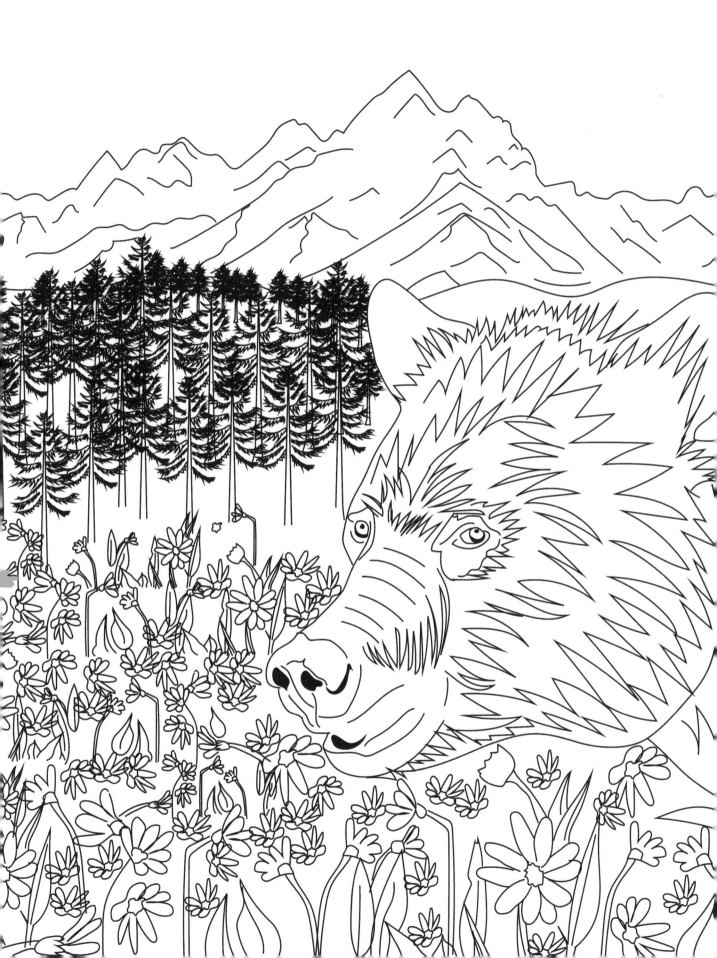

Great Smoky Mountains (North Carolina, Tennessee)
The most visited national park in the US, the Great Smoky Mountains is named for
the ever-present fog and contains a great diversity of plants and wildlife.
Many flock to Cades Cove to see its first permanent European settler
John Oliver's cabin, which is held together by only notched corners.

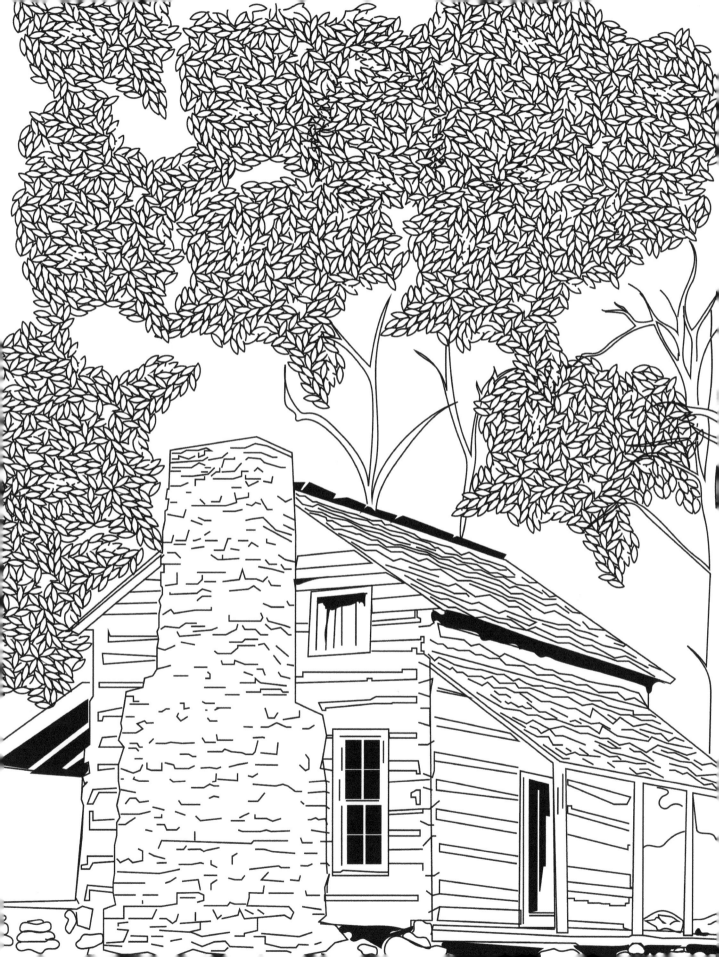

Haleakalā National Park (Hawai'i)

The summit of the dormant Haleakalā ("House of the Sun") volcano is a dramatic, colorful landscape (especially when it is sunrise) and is where many rare and endemic plant species live. In fact, it has more endangered species than any other national park.

The mountain is sacred to indigenous Hawaiians and is where the goddess Pele crafted her cinder cones and where the demigod Maui lassoed the sun to slow it down for crops to grow.

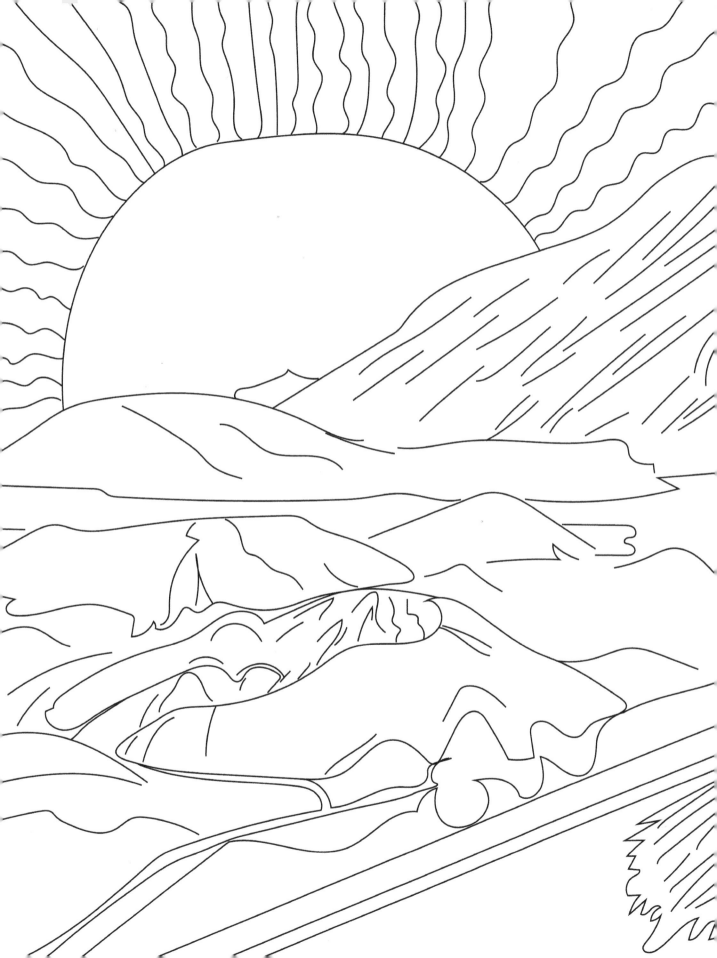

Hawai'i Volcanoes National Park (Hawai'i)

The national park has vastly different landscapes within, from tropical rainforests
to sulphur springs to lava fields. Home to Mauna Loa, earth's most massive mountain,
as well as Kilauea, a volcano continuously active since 1983, Hawai'i Volcanoes National Park
also has rich cultural history, containing over 23,000 petroglyphs at Pu`u Loa.

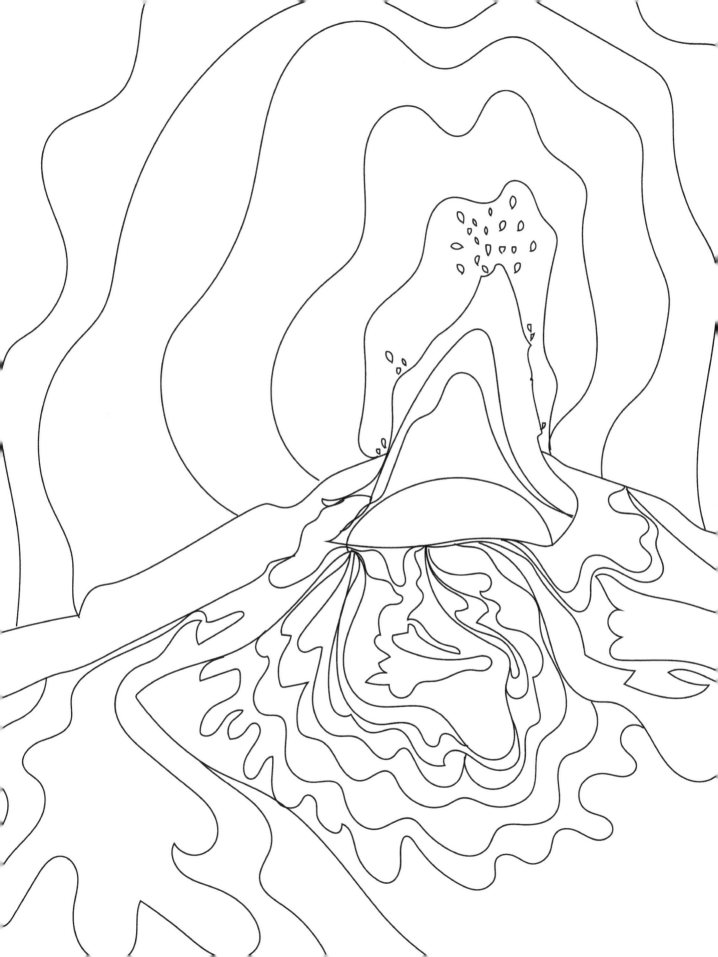

Hot Springs National Park (Arkansas)

Once known as Hot Springs Reservation and called "The American Spa," this national park's 47 hot springs from Hot Springs Mountain attracted so many people that a city was built around them. The Grand Promenade is a half-mile brick trail behind Bathhouse Row and begun construction in the 1930s before finally being completed in 1957.

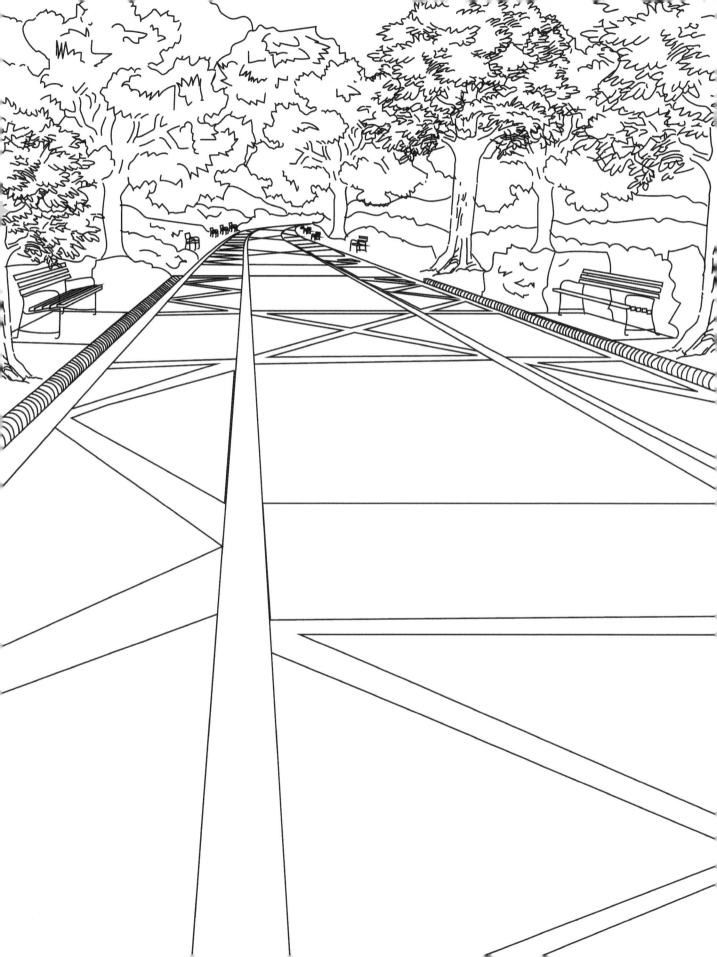

Joshua Tree National Park (California)

Straddling where the Mojave Desert and Sonoran Desert meet, this national park is named for the twisted, spiky monocots that dominate the landscape. Joshua trees can live around 150 years or even longer, and rely on perfect conditions of rain and freeze to proliferate.

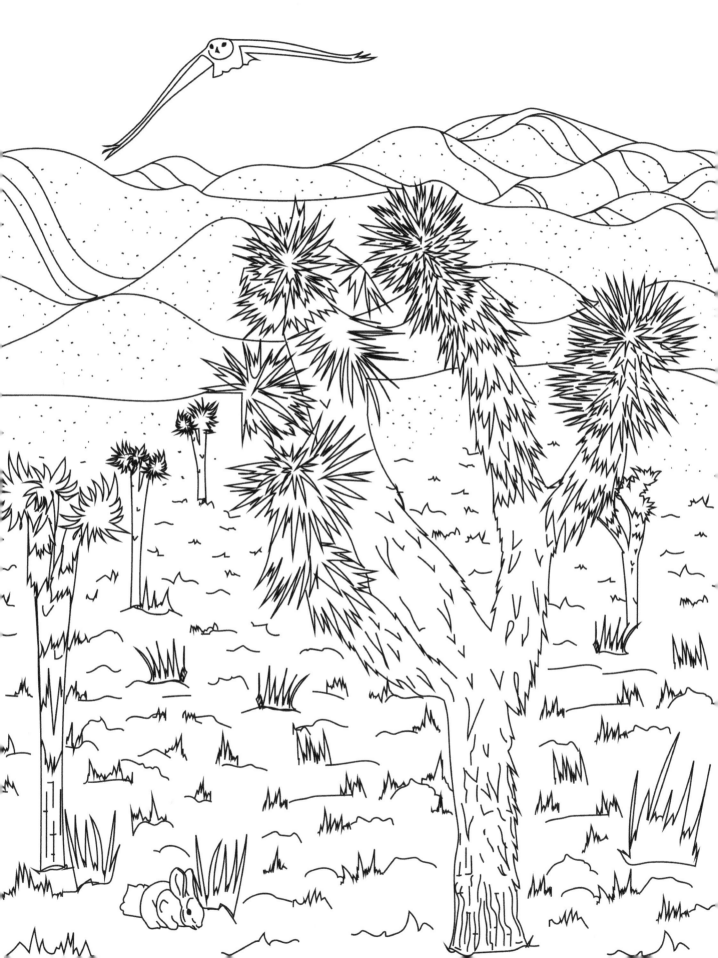

Mount Rainier National Park (Washington)

The iconic mountain of the state of Washington, Mount Rainier is an active volcano and the most glaciated peak in the contiguous US. As the highest volcano in the Cascade Range, Mount Rainier also has 25 named glaciers.

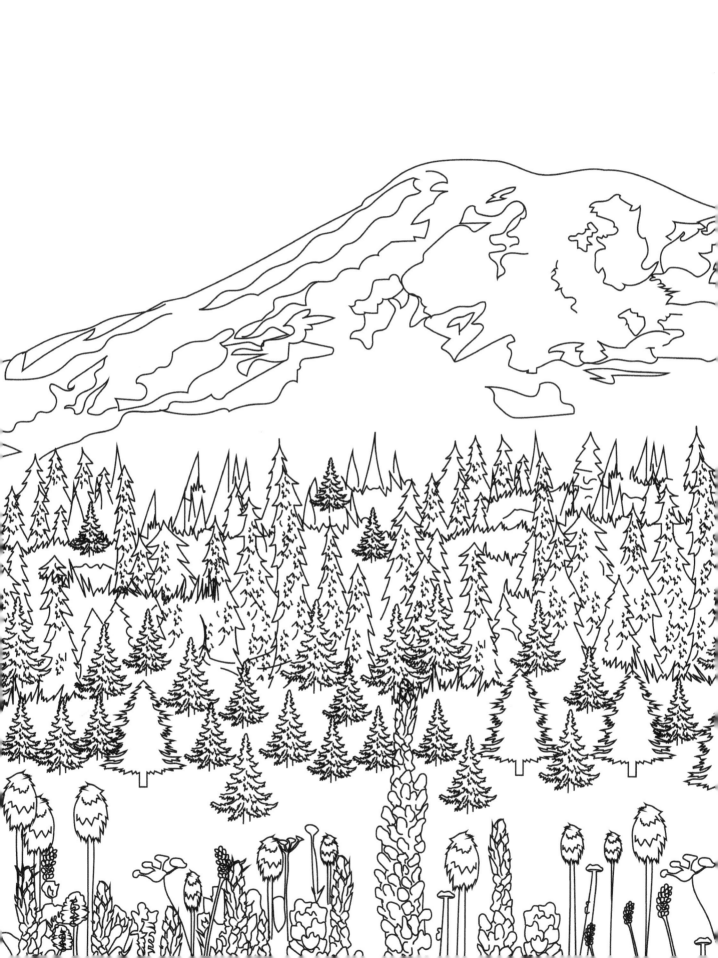

Olympic National Park (Washington)

Olympic has over 650 archaeological sites and has a wide range of ecosystems, from glacier-capped mountains to temperate rain forests to lush forests. In the Hoh Rain Forest loops the Hall of Mosses trail, where one may find elk and other wildlife.

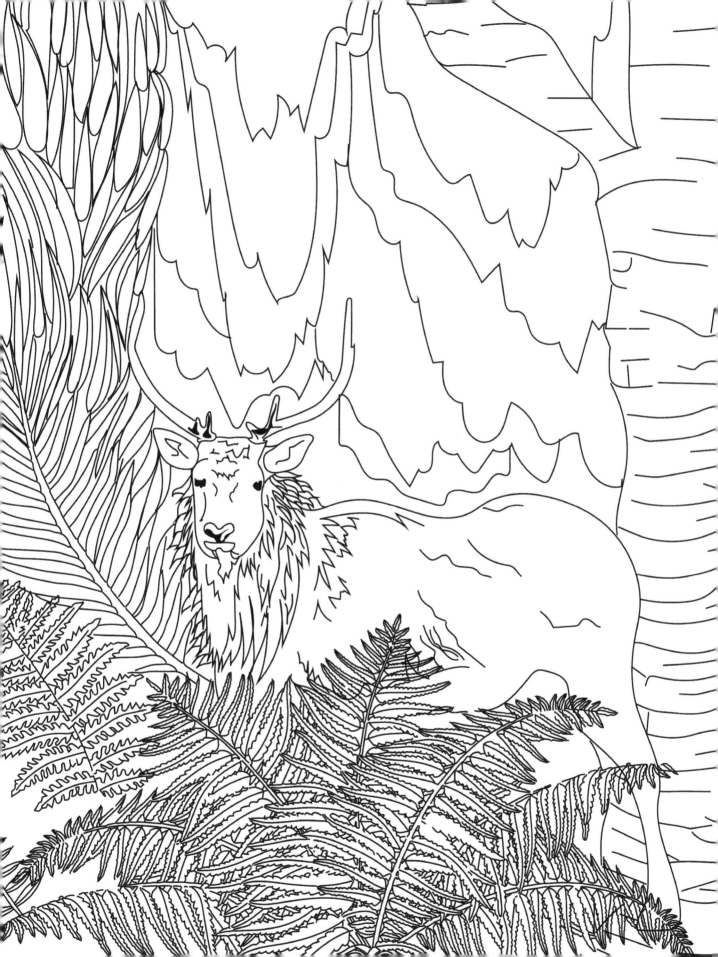

Padre Island National Seashore (Texas)

Named the longest stretch of undeveloped barrier island in the world,
Padre Island is the nesting ground for all five sea turtle species found in
the Gulf of Mexico, including the Kemp's ridley sea turtle. The sea turtle is the
most iconic animal at Padre Island, and there are even public hatchling releases.

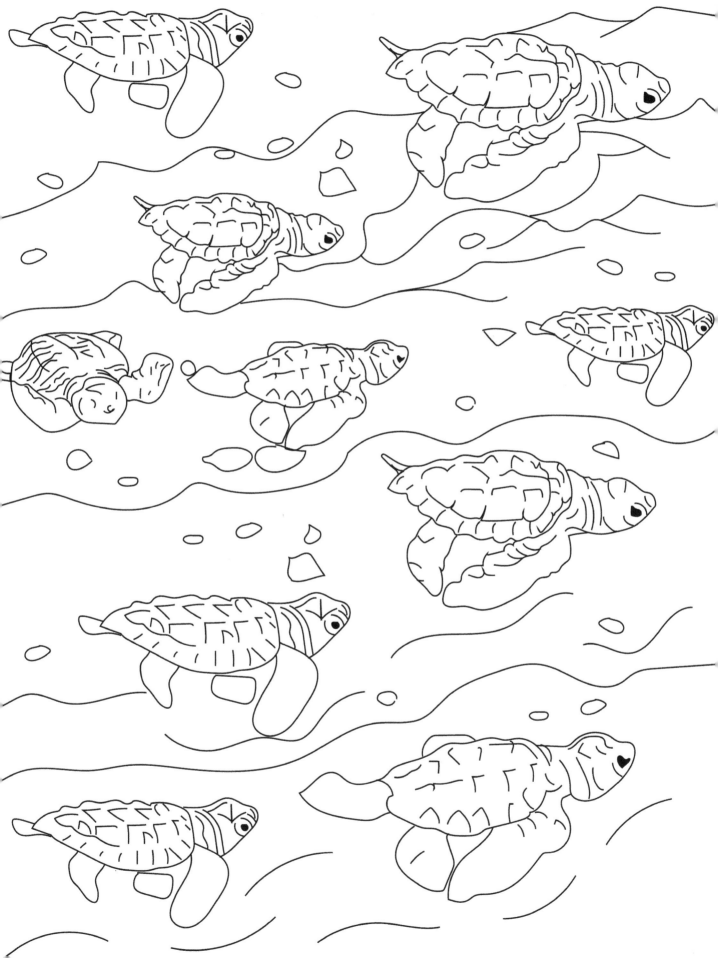

Pinnacles National Park (California)

Pinnacles was formed 23 million years ago from lava flows and landslides created by volcanic eruptions, and has since been shaped by erosive forces. Today the park is made of dramatic rock peaks, chaparral, grasslands, talus caves, and woodlands.

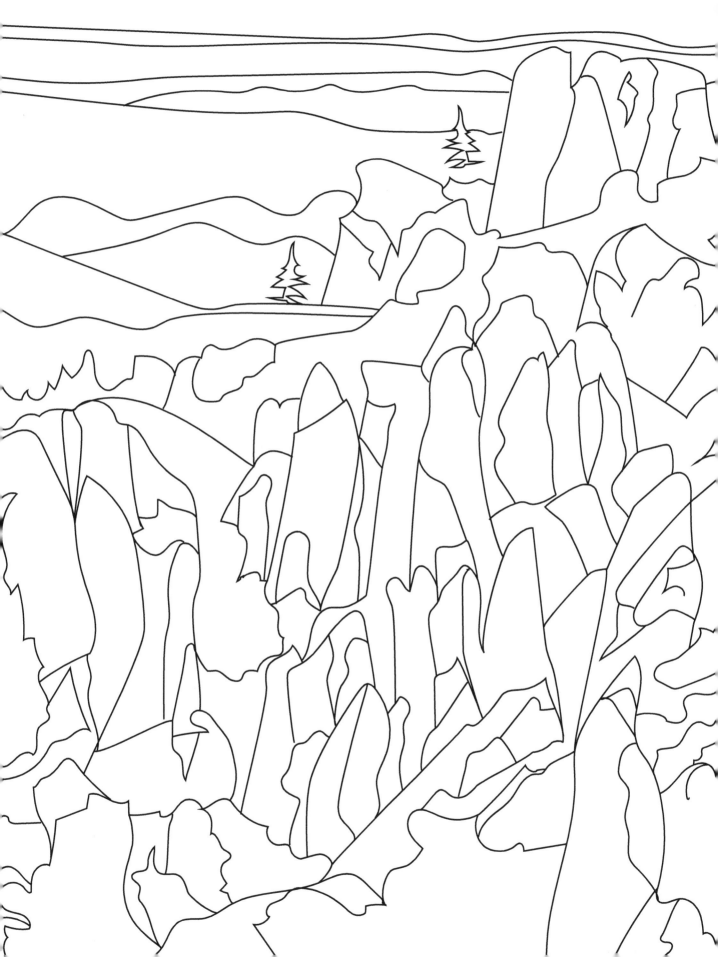

Redwood National Park (California)

Home to the tallest trees on earth, the Redwoods is actually both a state and national park, managed by both California and the US government. The Tall Trees Grove is home to the 368-foot Libby Tree, or Tall Tree, known as the world's tallest tree until 1994. The tree actually lost a section of its top in a 1996 storm.

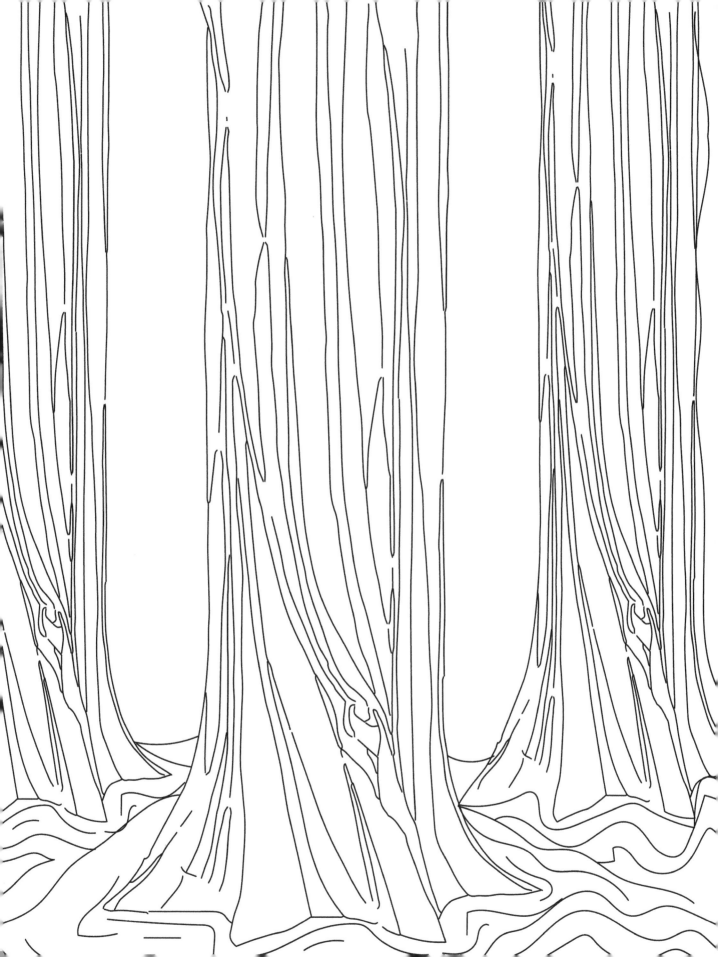

Rocky Mountain National Park (Colorado)

The Rocky Mountain National Park straddles the Continental Divide with Longs Peak as its highest summit at 14,259 feet. Elk can be found throughout the park and on the fragile alpine tundra, which composes of one-third of the park.

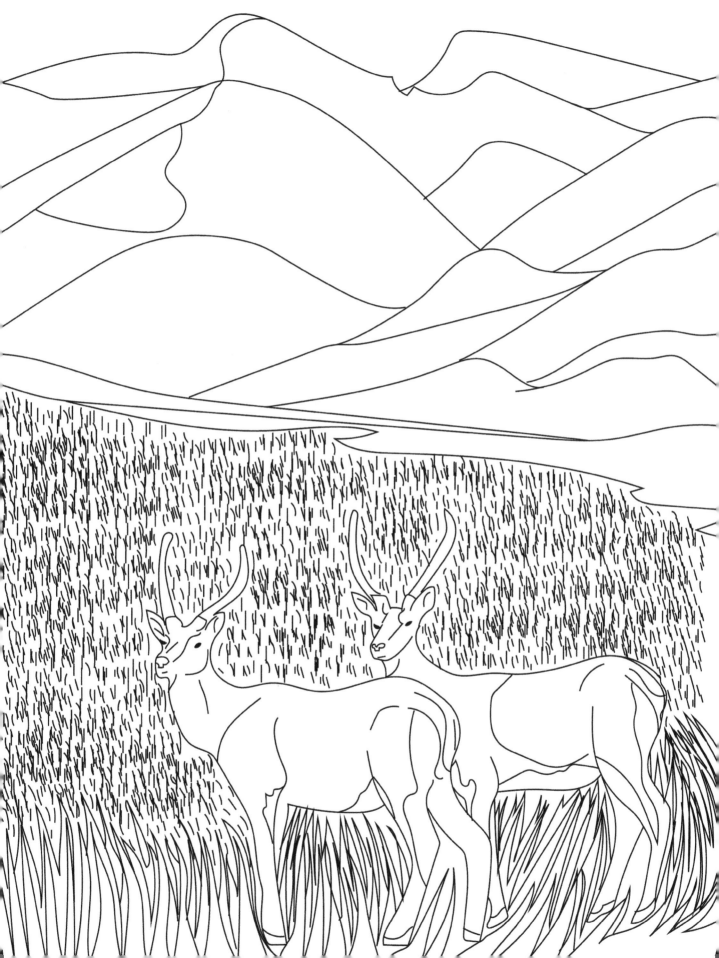

Saguaro National Park (Arizona)

Home to 25 species of cacti, Saguaro National Park is named for the largest and perhaps most iconic cactus plant in the US. Saguaros may live over 200 years and be as tall as 50 feet, and provide for woodpeckers, owls, jackrabbits, bighorn sheep, and many more.

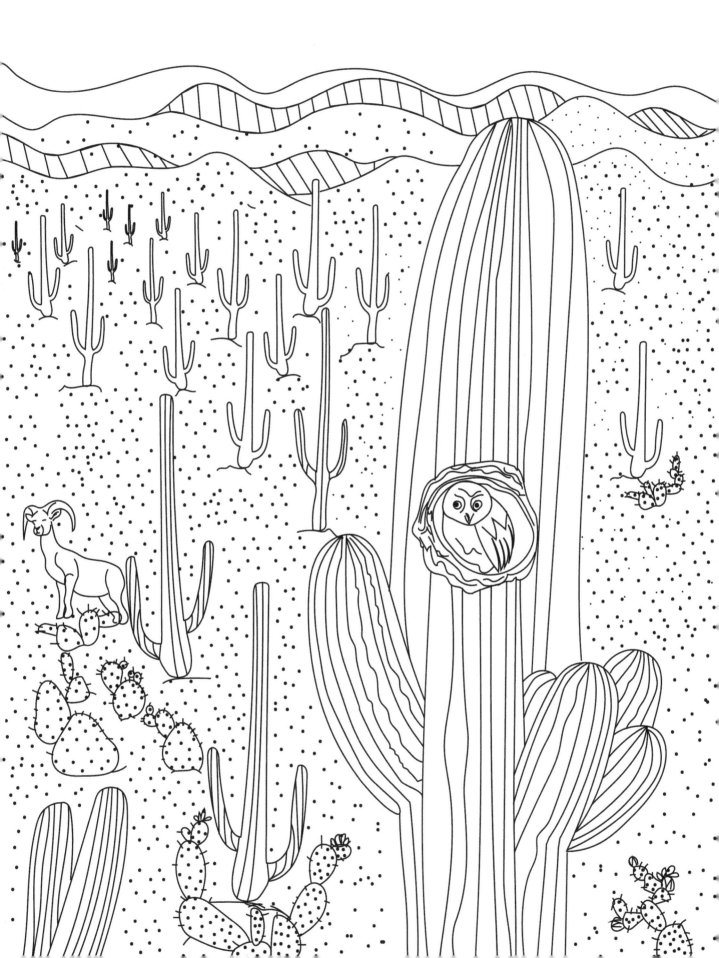

Sequoia National Park (California)

This park has the largest trees in the world. Giant sequoia trees can live for over 3,000 years and are adapted to periodic fire with their thick, fibrous bark. General Sherman Tree is the world's largest tree by volume, standing at 275 feet tall and over 36 feet in diameter at the base.

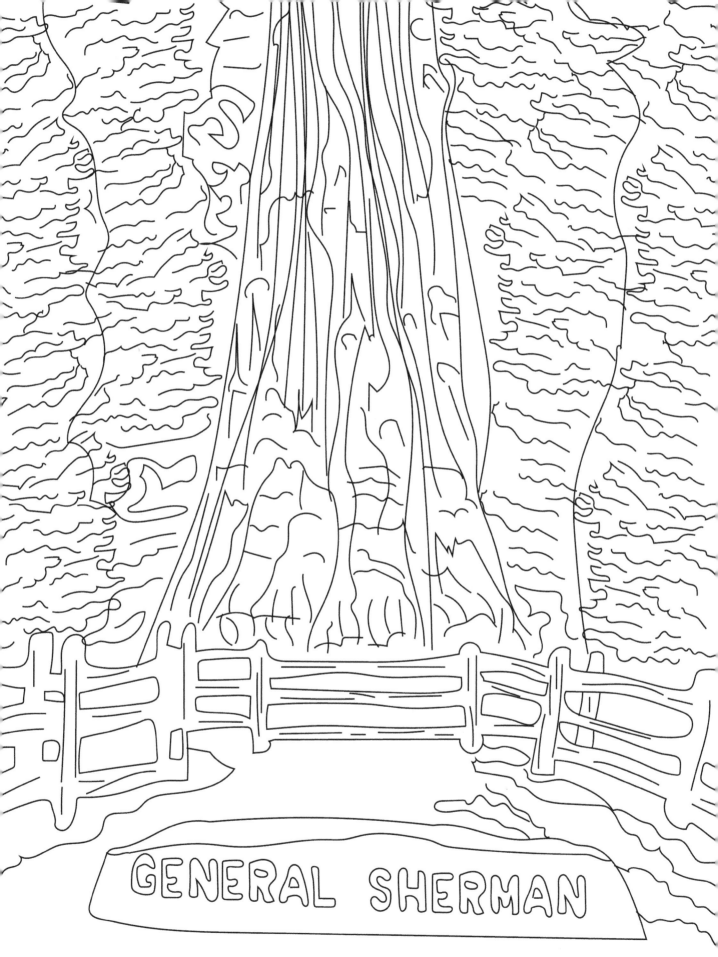

GENERAL SHERMAN

Shenandoah National Park (Virginia)

Most of Shenandoah is forest, but it also has some of the largest rock outcrops
in the region. One is Stony Man, a sheer cliff peak that is over
4,000 feet high, creating a mix of habitats in its great elevation range.

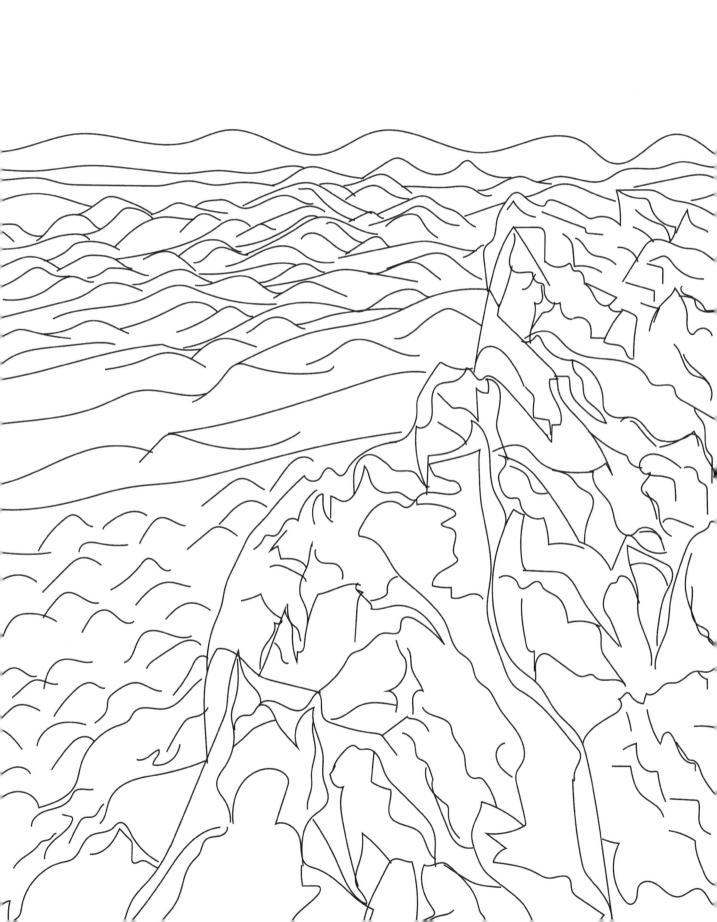

Yellowstone National Park (Wyoming, Montana, Idaho)

The world's first national park, Yellowstone is famous for its wildlife of grizzlies and wolves as well as its natural features including geysers, like Old Faithful, and hot springs, like the colorful Grand Prismatic Spring. Grand Prismatic is Yellowstone's largest hot spring, about 370 feet in diameter and more than 121 feet deep.

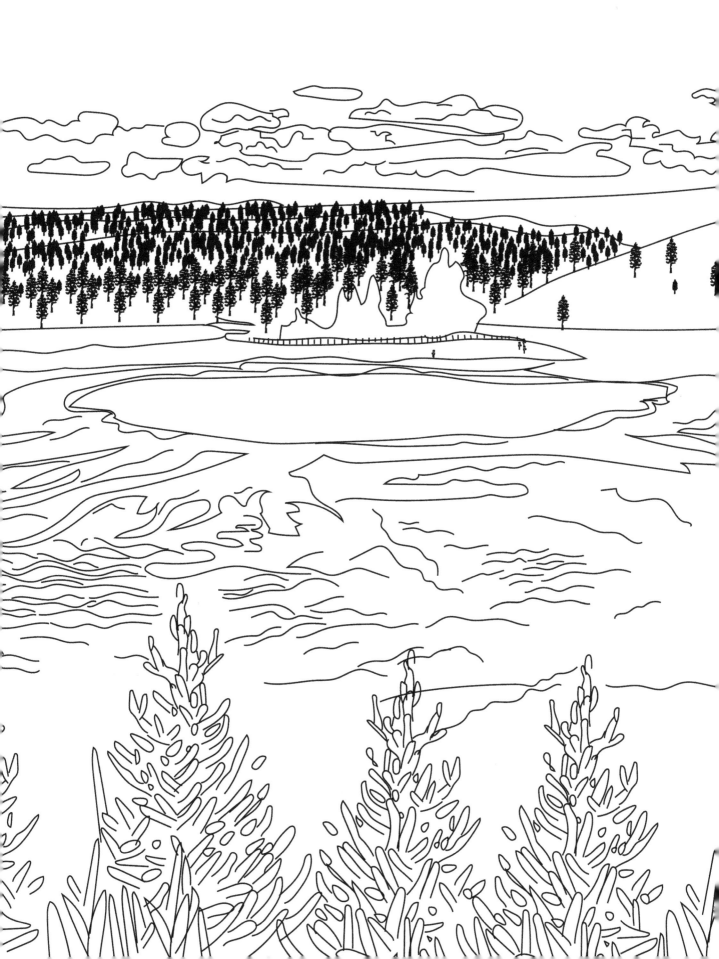

Yosemite National Park (California)

Yosemite is perhaps best known for its waterfalls and deep granite valleys, carved
from rivers and glaciers to create unique formations. Tunnel View is a favorite spot to view
Yosemite Valley and nearby features, including El Capitan, Bridalveil Fall, and Half Dome.

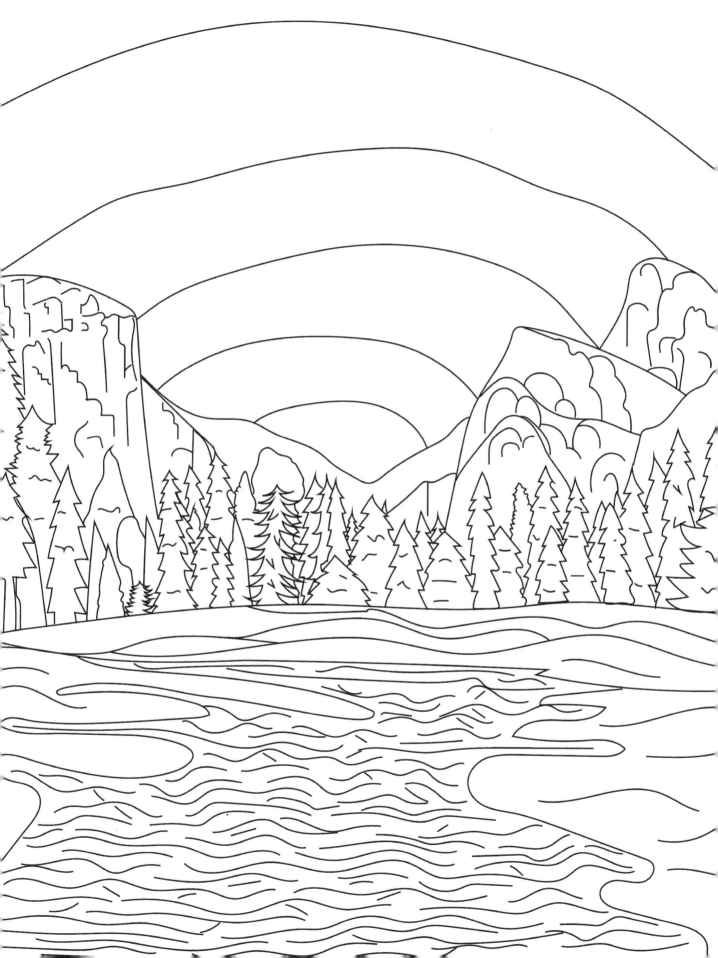

Zion National Park (Utah)

Zion gives the unique experience of walking in narrow passages surrounded by towering cliffs. The park's most popular hike as well as narrowest section, The Narrows is a gorge with sandstone walls 1,000 feet tall through the Virgin River that can be 20–30 feet wide.

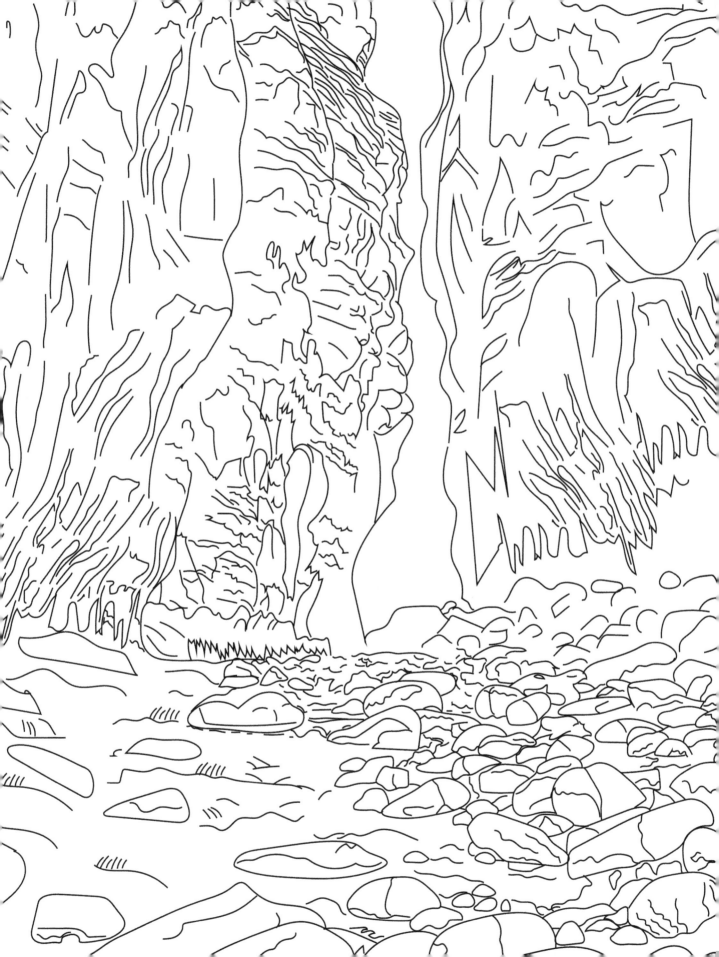

ISBN: 9781513261942

LSI November 2019

Proudly distributed by Ingram Publisher Services.

Graphic Arts Books
is an imprint of

WEST
MARGIN
PRESS
WestMarginPress.com

WEST MARGIN PRESS
Publishing Director: Jennifer Newens
Marketing Manager: Angela Zbornik
Editor: Olivia Ngai
Design & Production: Rachel Lopez Metzger